Dream Catcher
life on earth

by Christina Rose

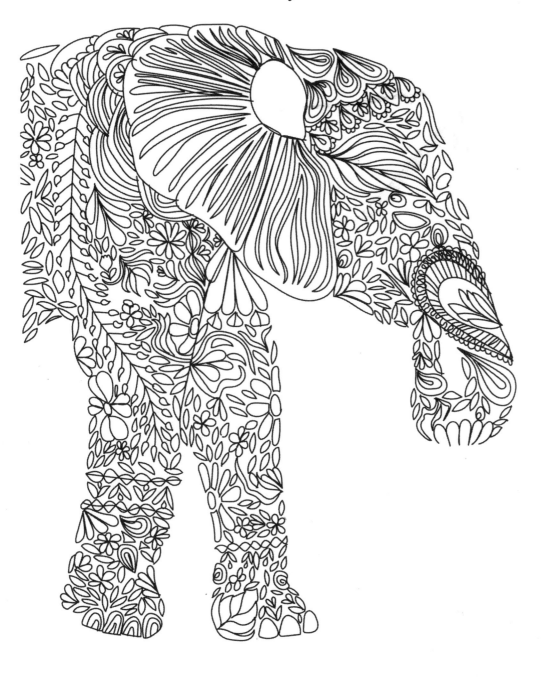

Dream Catcher: life on earth
A powerful & inspiring adult colouring book
celebrating the beauty of nature

First published in the United Kingdom in 2015 by
Bell & Mackenzie Publishing Limited

ISBN: 978-1-910771-35-8

A CIP catalogue record of this book is available from the British Library

Created by Christina Rose
Contributors: Letitia Clouden, Laura Vann

www.bellmackenzie.com

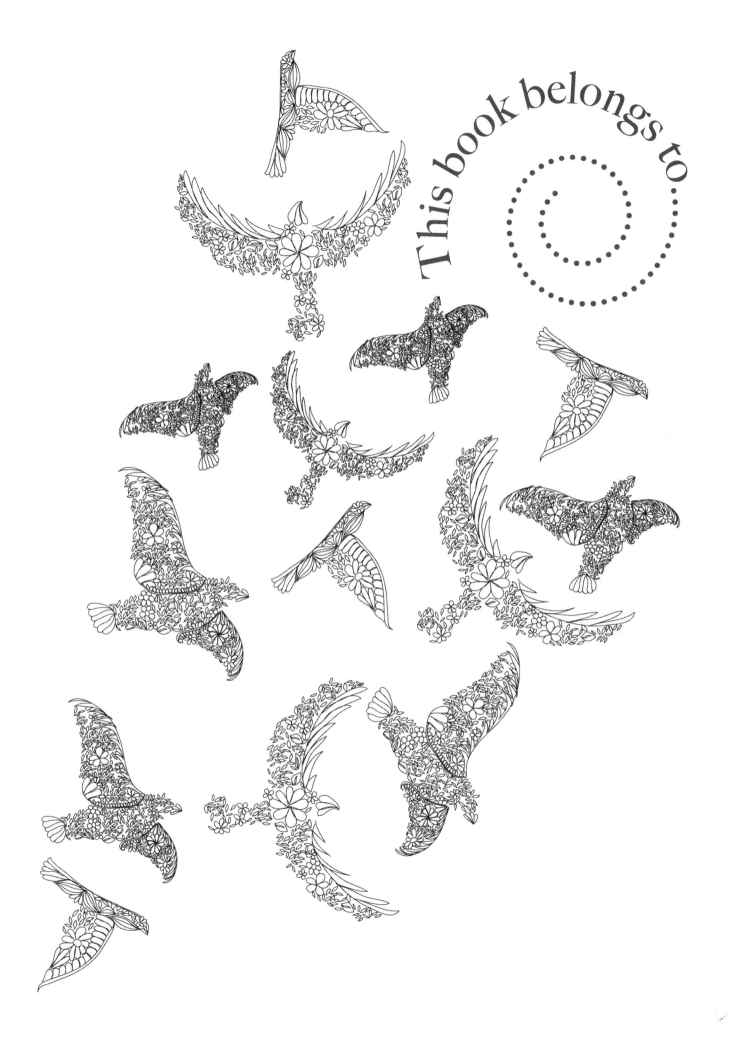

This book belongs to

Climb the mountains and get their good tidings. Nature's peace will flow into you as sunshine flows into trees. The winds will blow their own freshness into you, and the storms their energy, while cares will drop off like autumn leaves.

John Muir

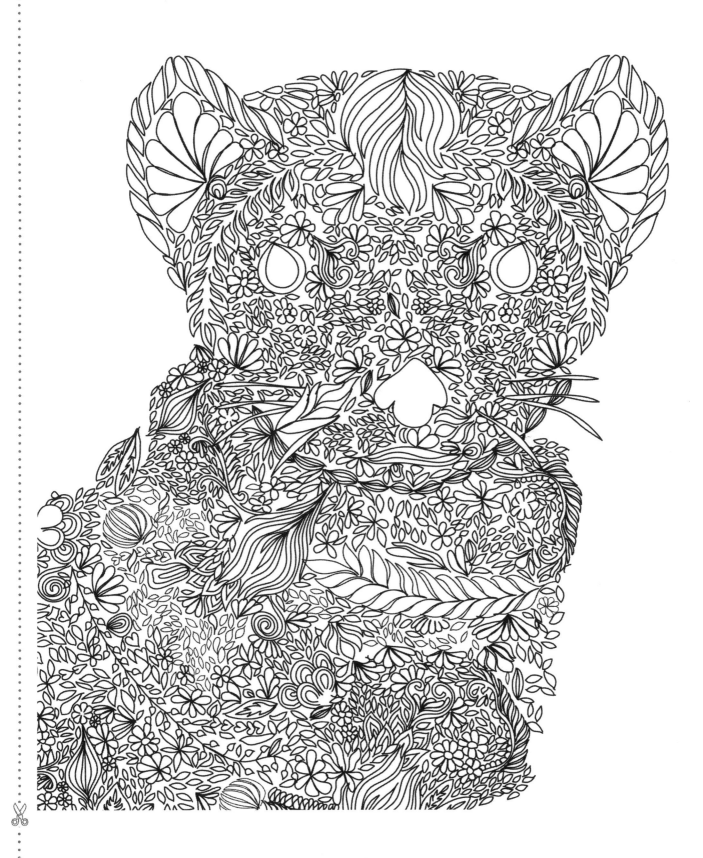

I believe that there is a subtle magnetism in Nature, which, if we unconsciously yield to it, will direct us aright.

Henry David Thoreau

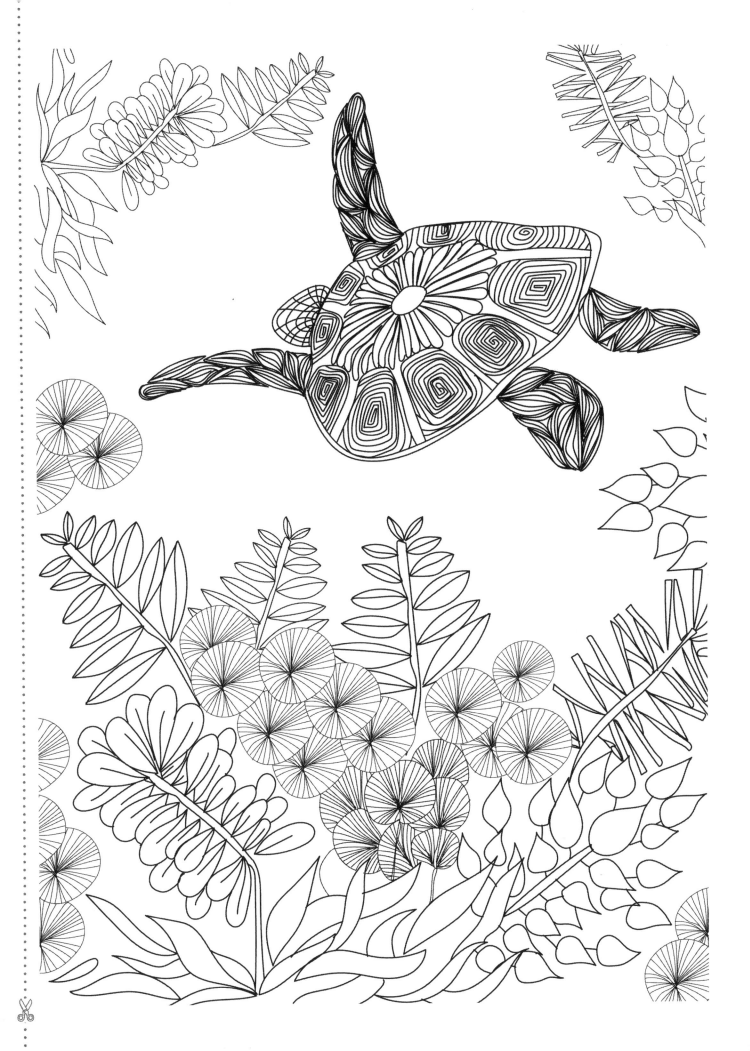

Look at the trees, look at the birds, look at the clouds, look at the stars... and if you have eyes you will be able to see that the whole existence is joyful. Everything is simply happy.

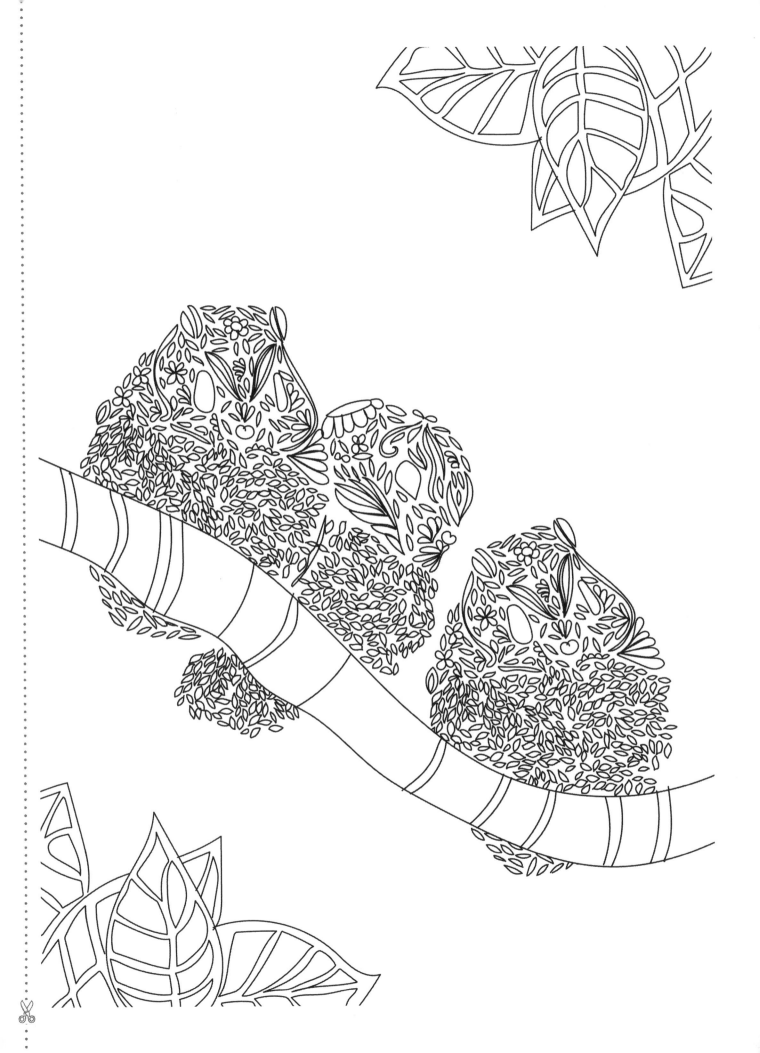

Be like the bird, who halting in his flight on limb too slight, feels it give way beneath him, yet sings knowing he hath wings.

Victor Hugo

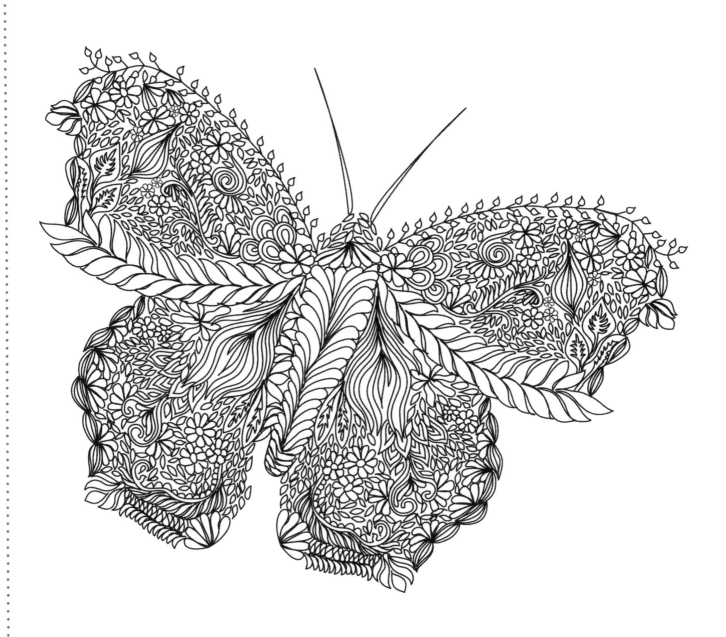

Those who wish to pet and baby wild animals 'love' them. But those who respect their natures and wish to let them live normal lives, love them more.

Edwin Way Teale

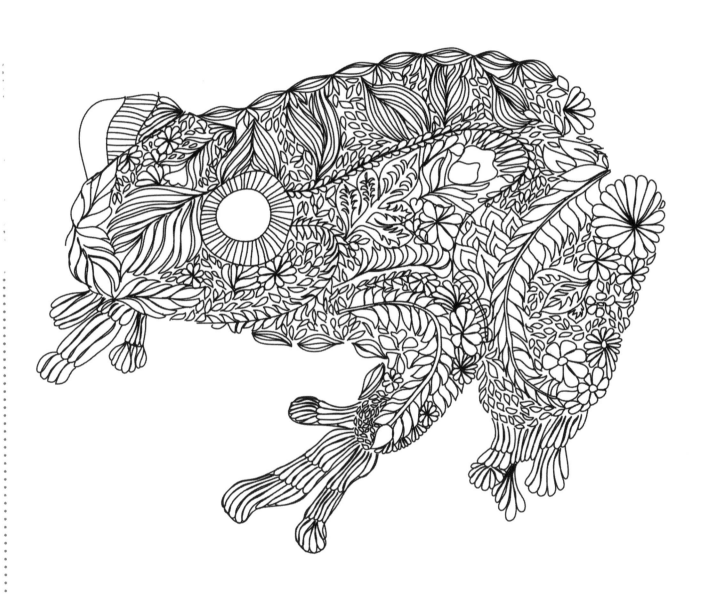

The truth is: the natural world is changing. And we are totally dependent on that world. It provides our food, water and air. It is the most precious thing we have and we need to defend it.

David Attenborough

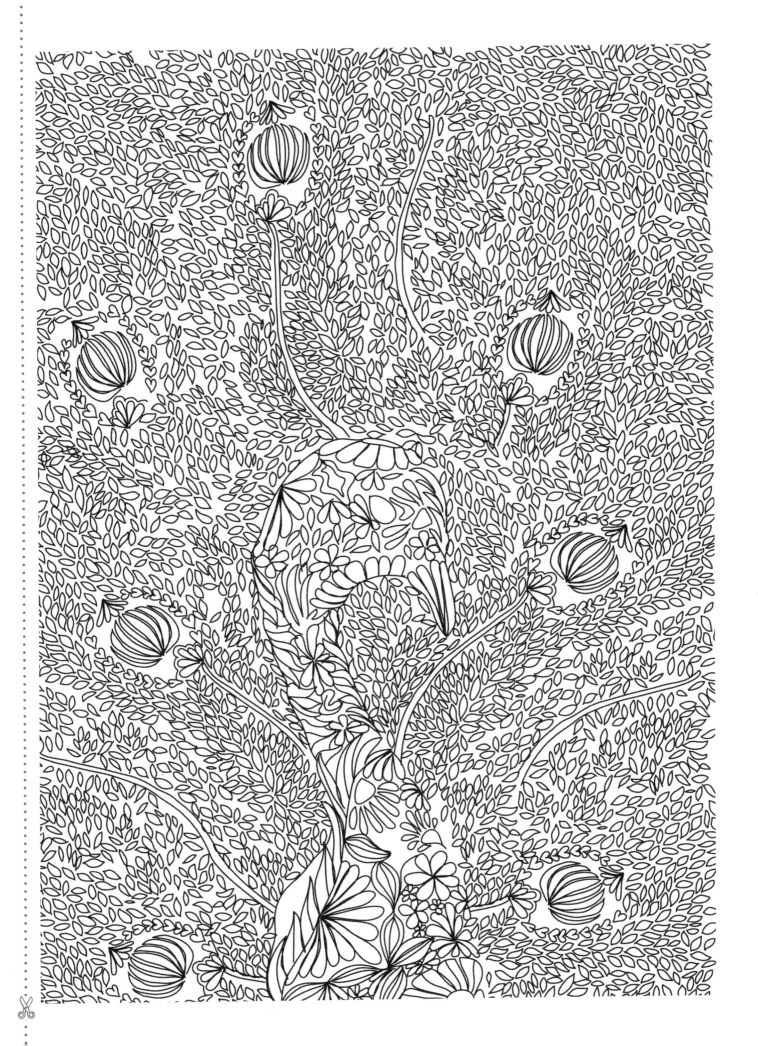

Even an animal, if you show genuine affection, gradually trust develops.... If you always showing bad face and beating, how can you develop friendship?

Dalai Lama

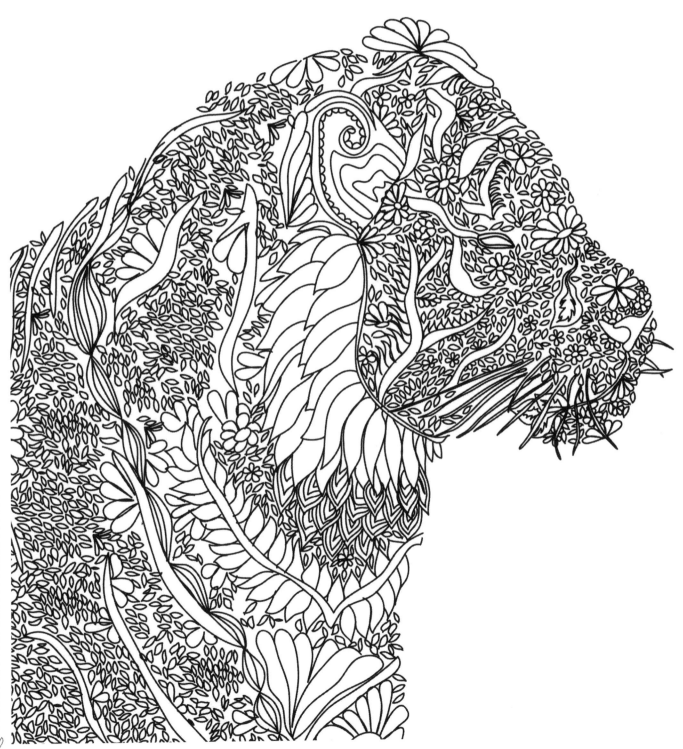

Wilderness is not a luxury but a necessity of the human spirit, and as vital to our lives as water and good bread. A civilization which destroys what little remains of the wild, the spare, the original, is cutting itself off from its origins and betraying the principle of civilization itself.

Edward Abbey

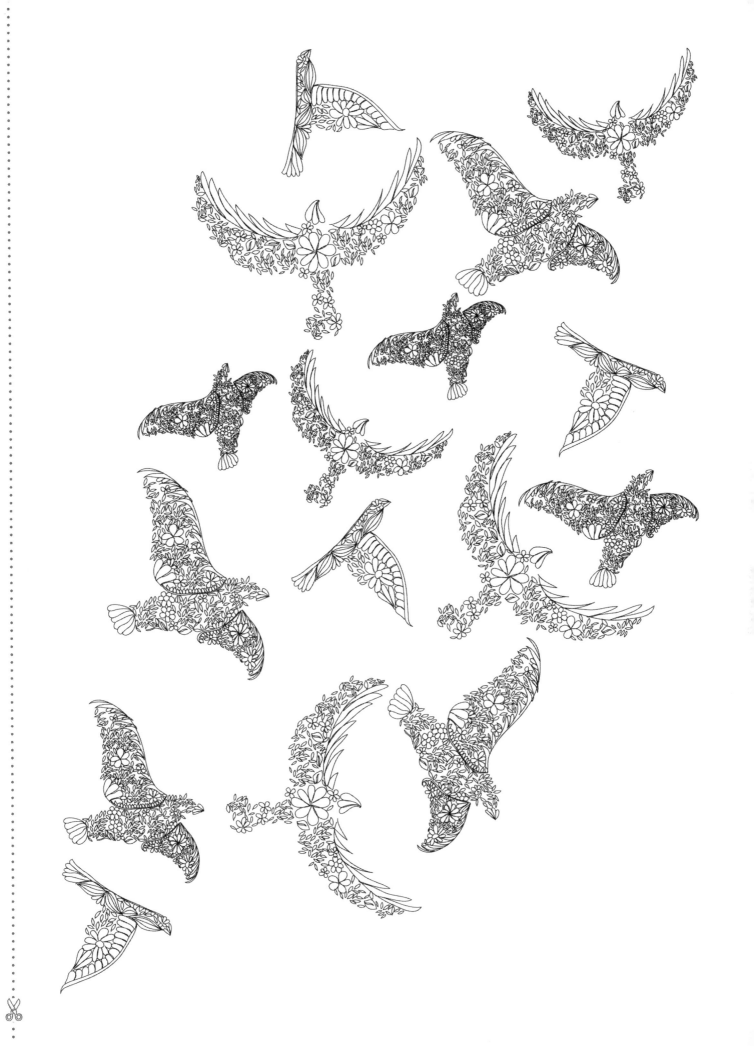

I only went out for a walk and finally concluded to stay out till sundown, for going out, I found, was really going in.

John Muir

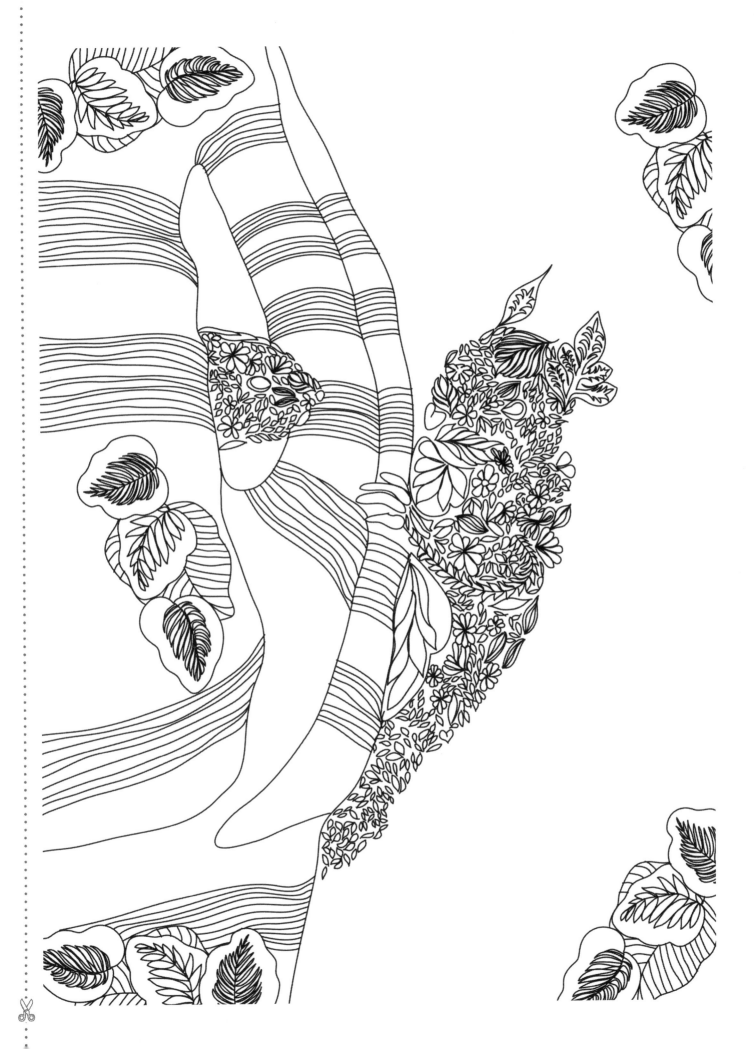

What humbugs we are, who pretend to live for Beauty, and never see the Dawn!

Logan Pearsall Smith

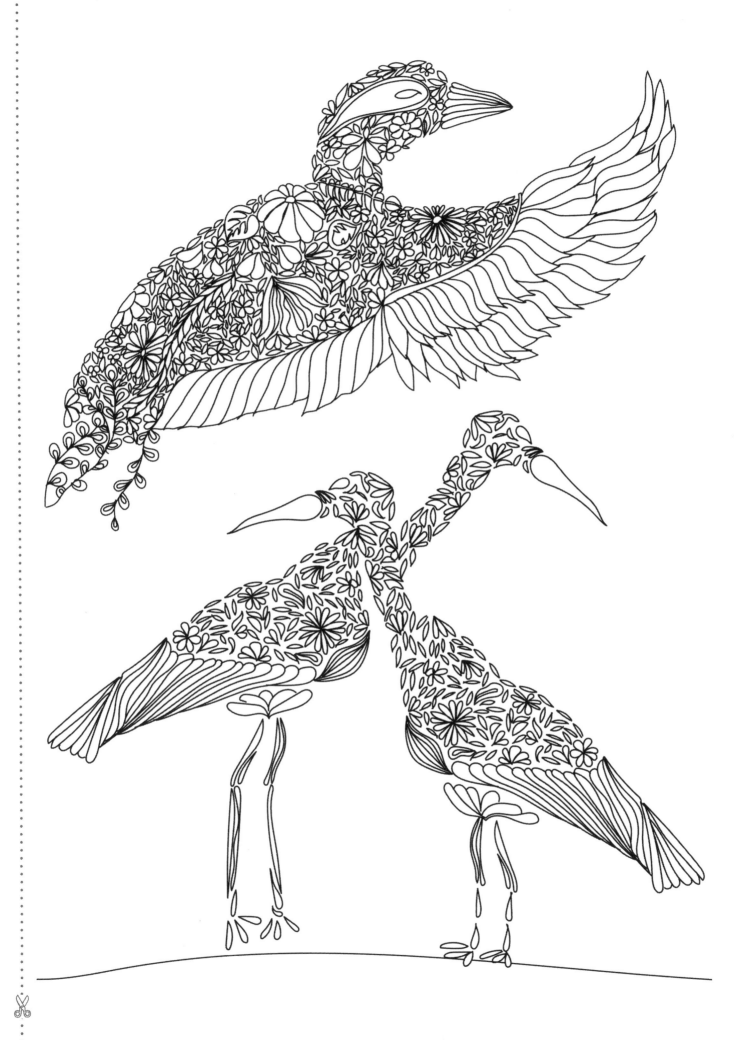

What we are doing to the forests of the world is but a mirror reflection of what we are doing to ourselves and to one another.

Mahatma Gandhi

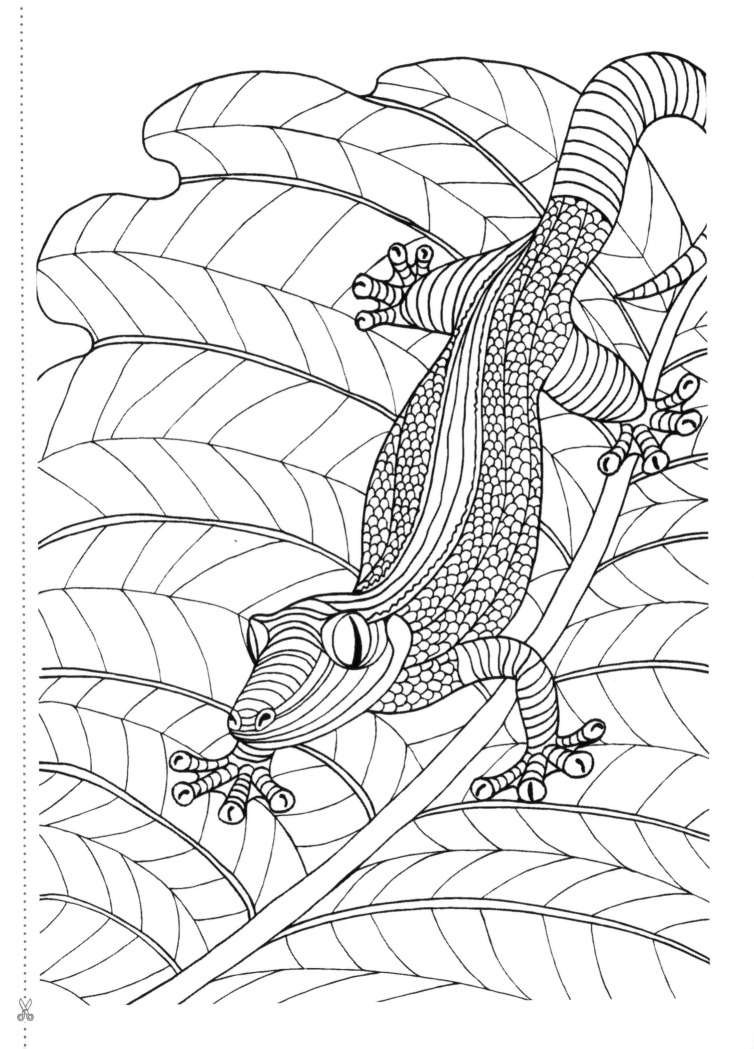

The greatness of a nation and its moral progress can be judged by the way its animals are treated.

Mahatma Gandhi

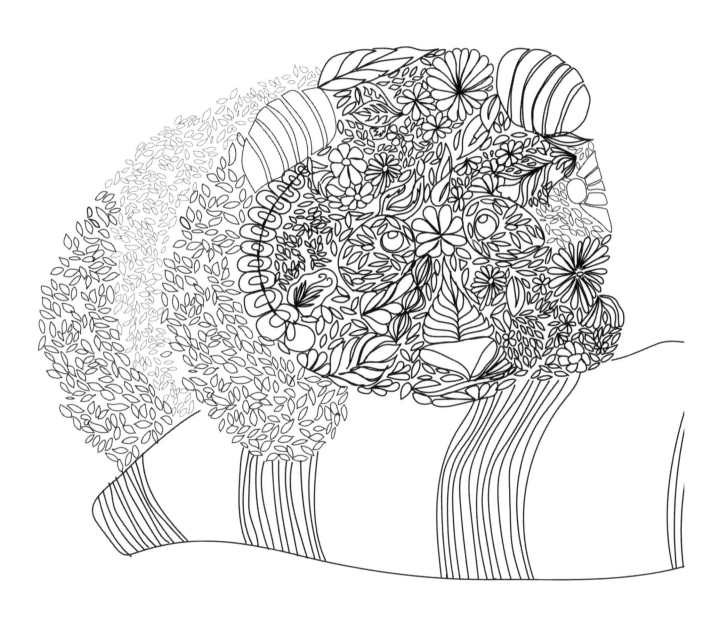

I love to think of nature as an unlimited broadcasting station, through which God speaks to us every hour, if we will only tune in.

George Washington Carver

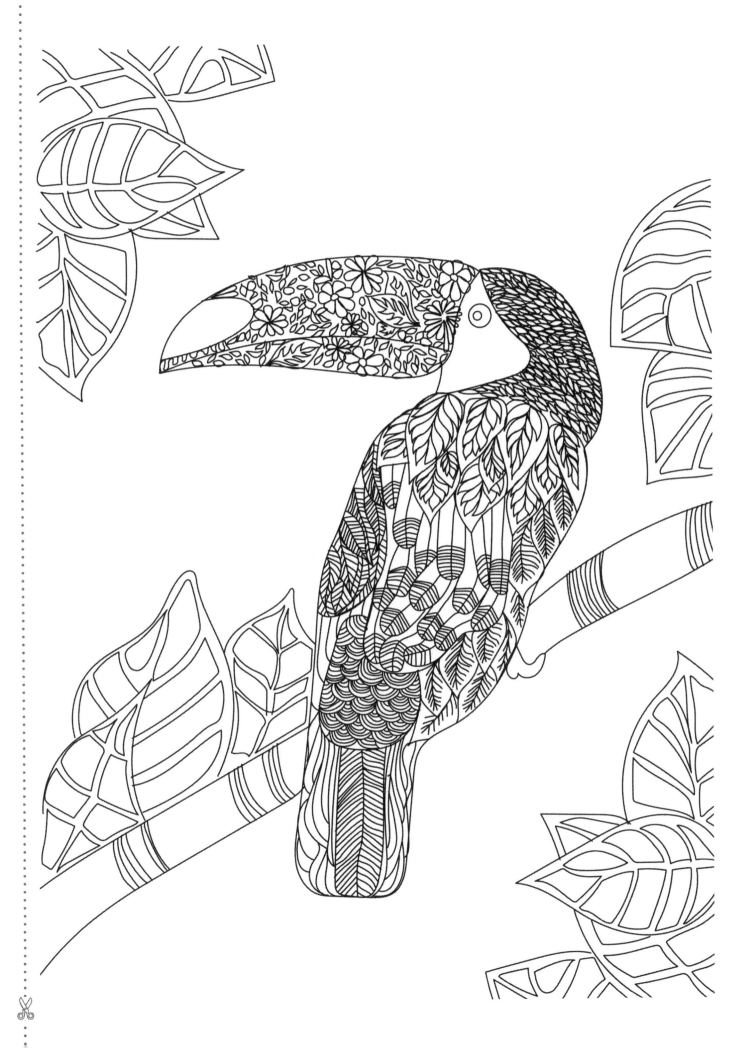

Until he extends the circle of his compassion to all living things, man will not himself find peace.

Albert Schweitzer

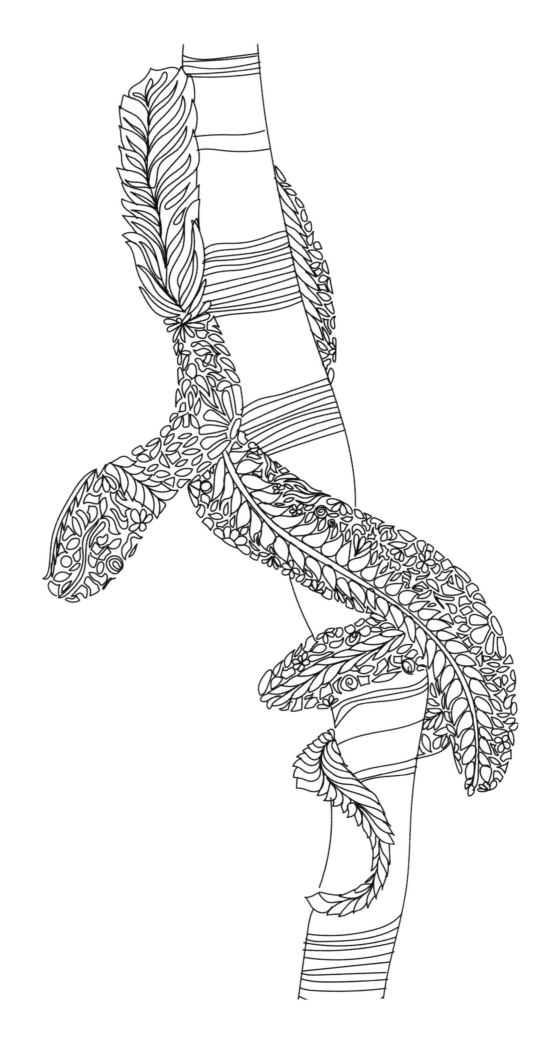

In wilderness I sense the miracle of life, and behind it our scientific accomplishments fade to trivia.

Charles A. Lindbergh

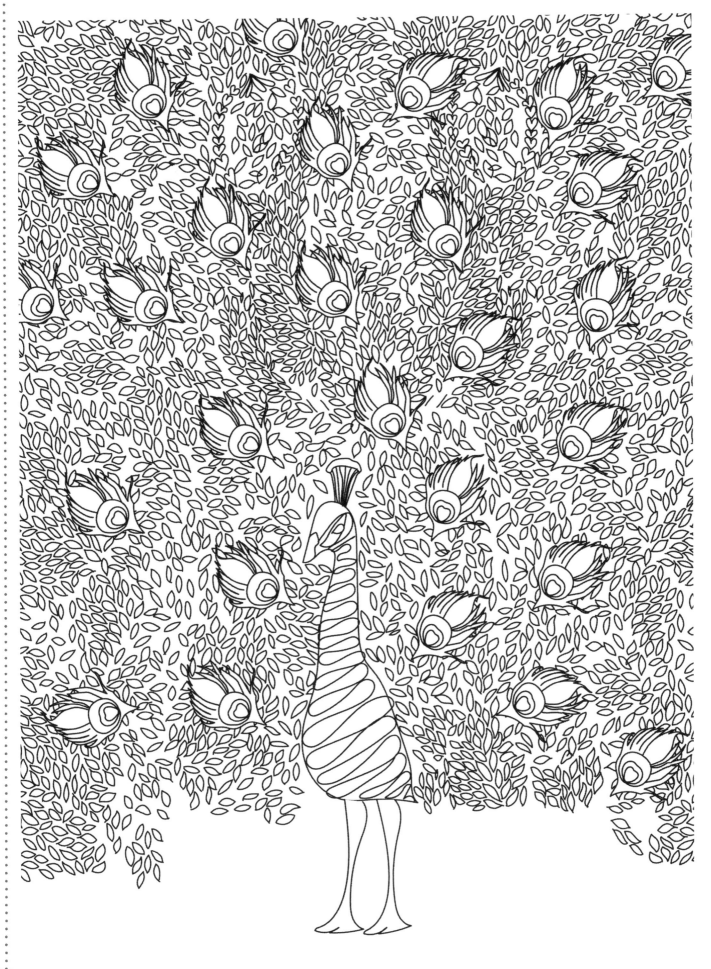

The human spirit needs places where nature has not been rearranged by the hand of man.

Author unknown

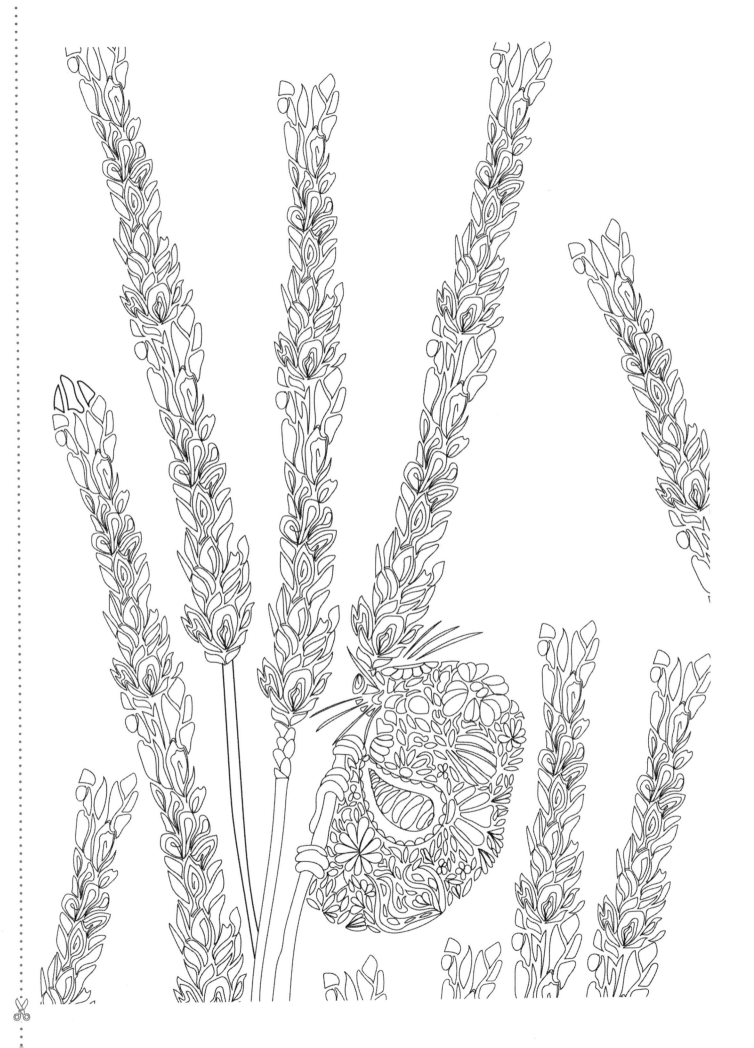

Life is as dear to a mute creature as it is to man. Just as one wants happiness and fears pain, just as one wants to live and not die, so do other creatures.

Dalai Lama

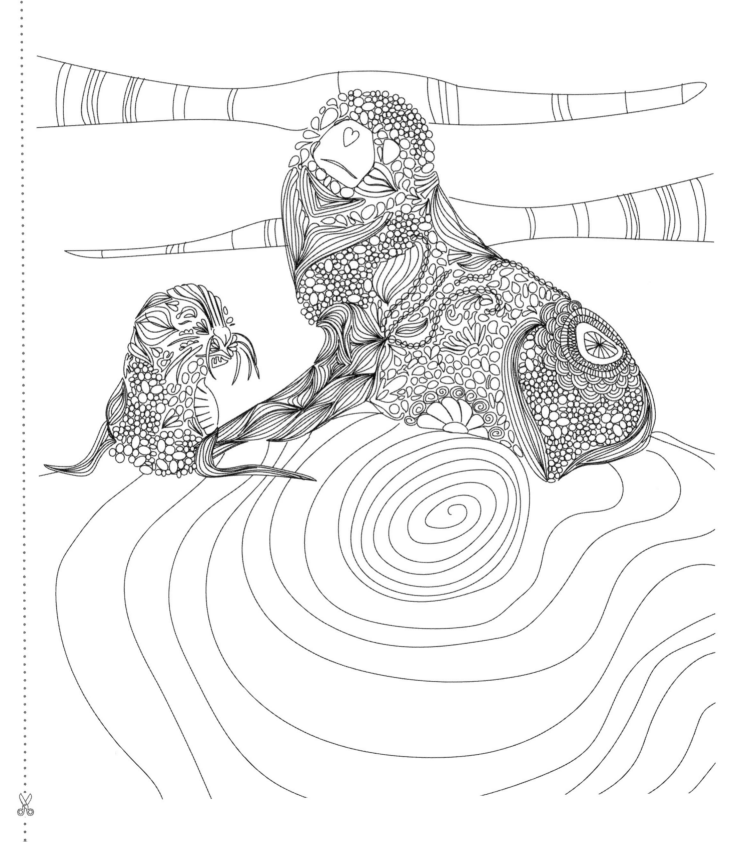

You can't be suspicious of a tree, or accuse a bird or a squirrel of subversion or challenge the ideology of a violet.

Hal Borland

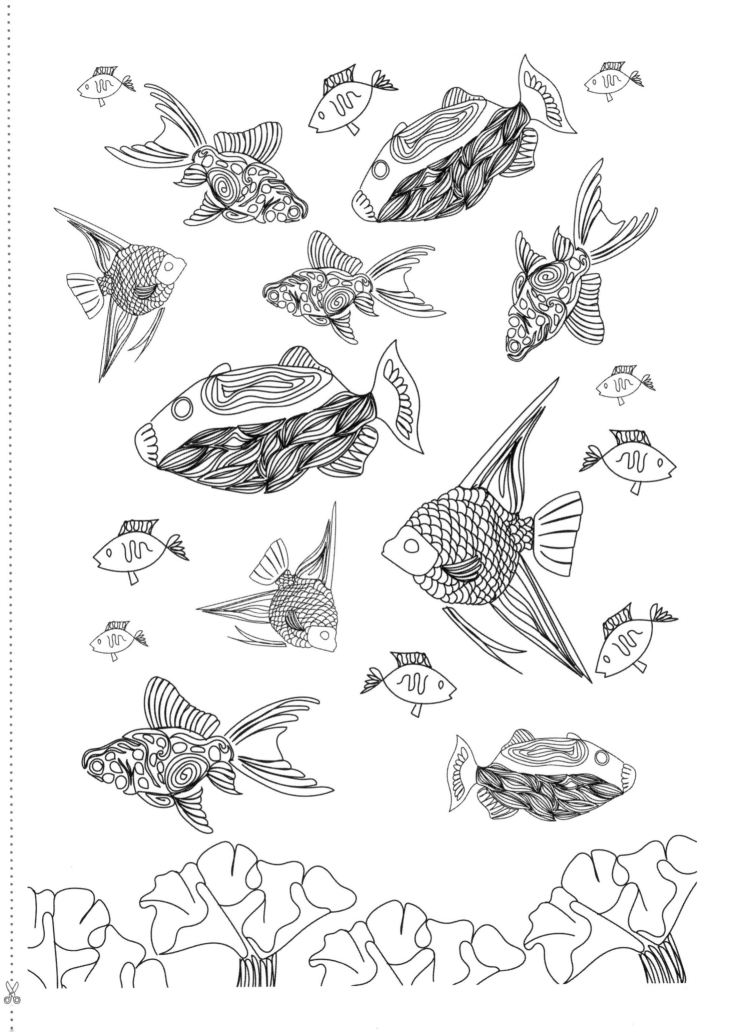

Those who dwell among the beauties and mysteries of the earth are never alone or weary of life.

Rachel Carson

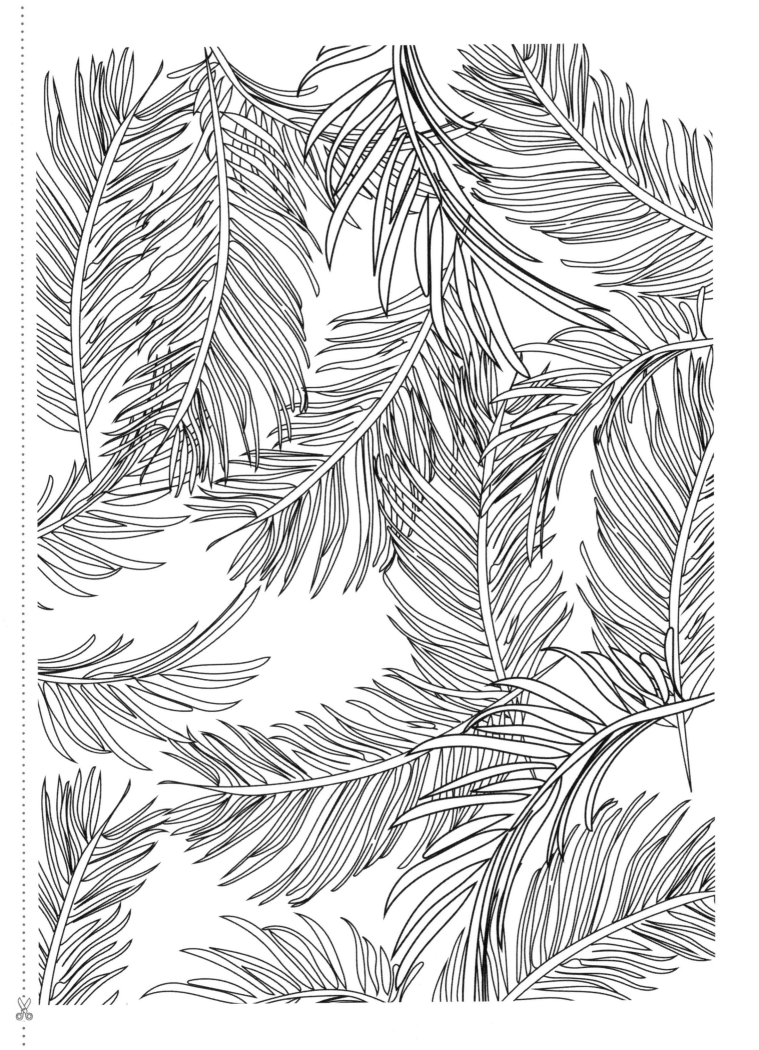

The sun shines not on us but in us. The rivers flow not past, but through us. Thrilling, tingling, vibrating every fiber and cell of the substance of our bodies, making them glide and sing.

John Muir

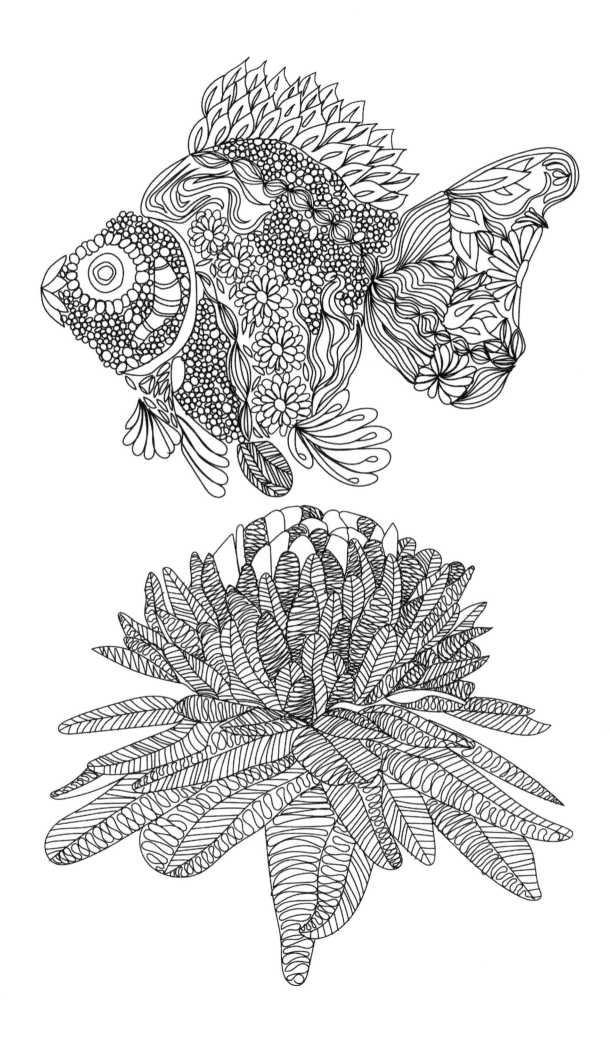

We do not inherit the earth from our ancestors; we borrow it from our children.

Ancient Native American Saying

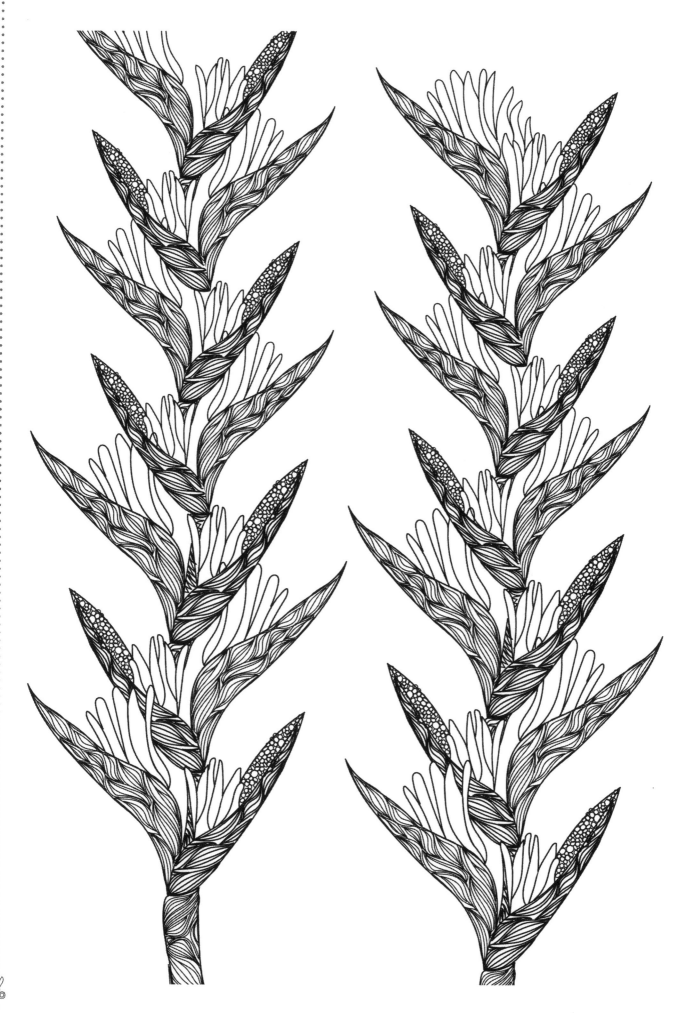

I am part of the sun as my eye is part of me. That I am part of the earth my feet know perfectly, and my blood is part of the sea. There is not any part of me that is alone and absolute except my mind, and we shall find that the mind has no existence by itself, it is only the glitter of the sun on the surfaces of the water.

D. H. Lawrence

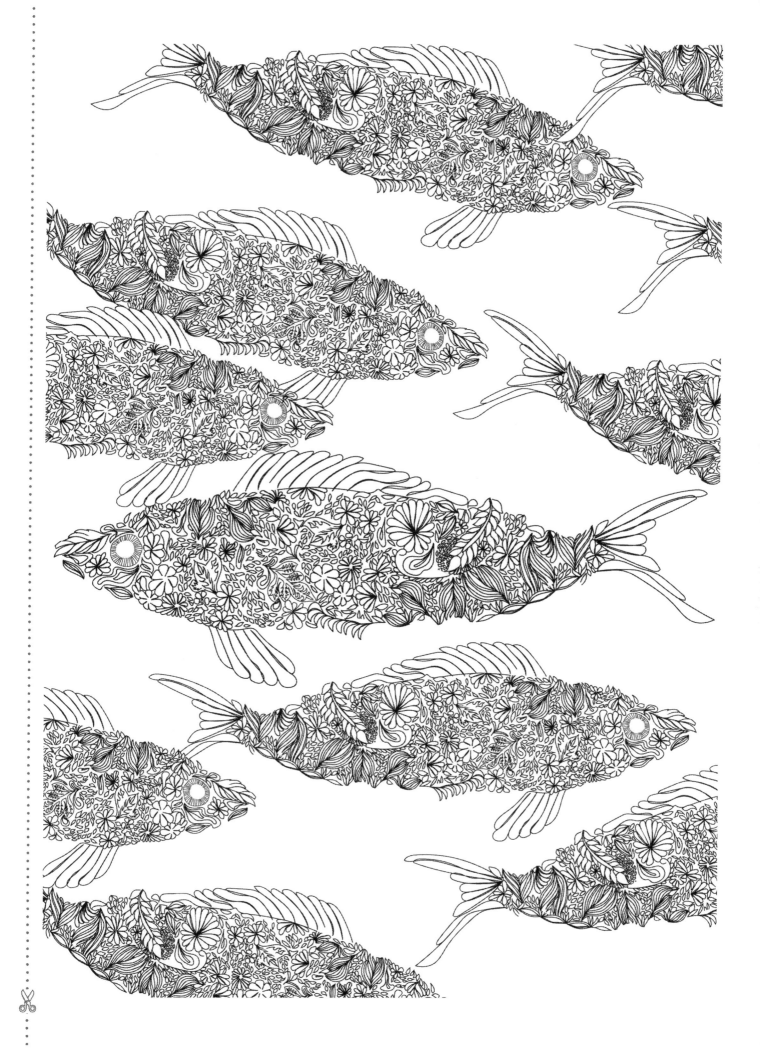

I am comforted by life's stability, by earth's unchangeableness. What has seemed new and frightening assumes its place in the unfolding of knowledge. It is good to know our universe. What is new is only new to us.

Pearl S. Buck

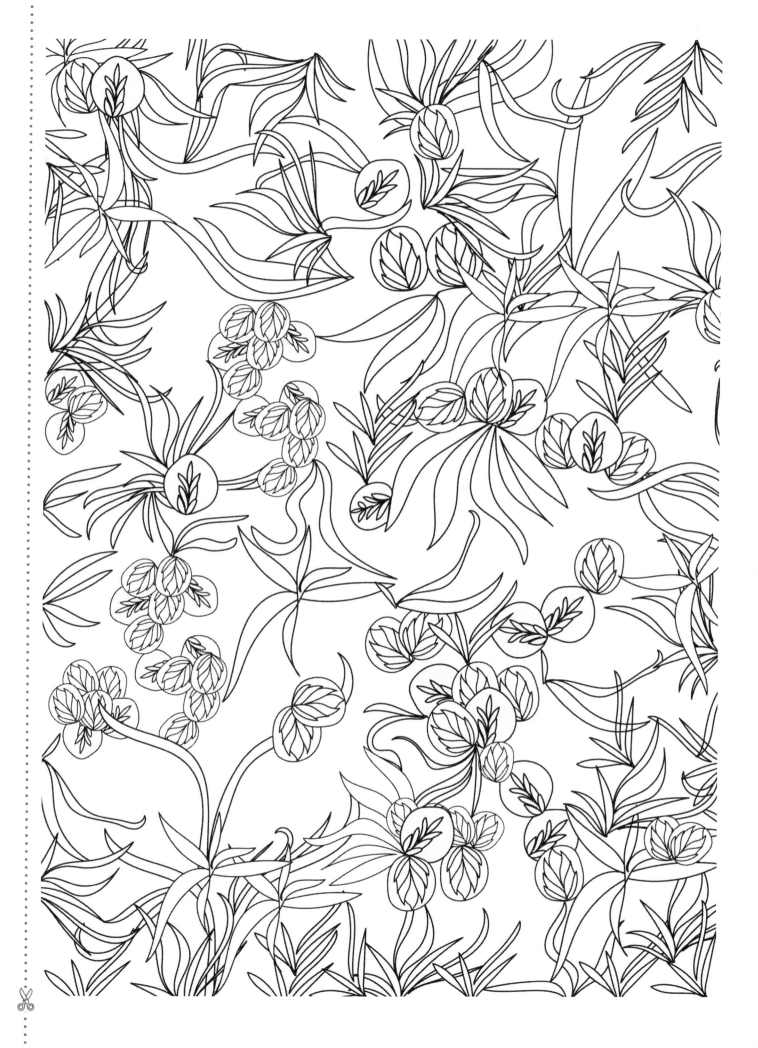

I think that I shall never see, a poem lovely as a tree. A tree whose hungry mouth is pressed against the earth's sweet flowing breast; a tree that looks at God all day, and lifts her leafy arms to pray; A tree that may in Summer wear a nest of robins in her hair; upon whose bosom snow has lain; who intimately lives with rain. Poems are made by fools like me, but only God can make a tree.

Joyce Kilmer

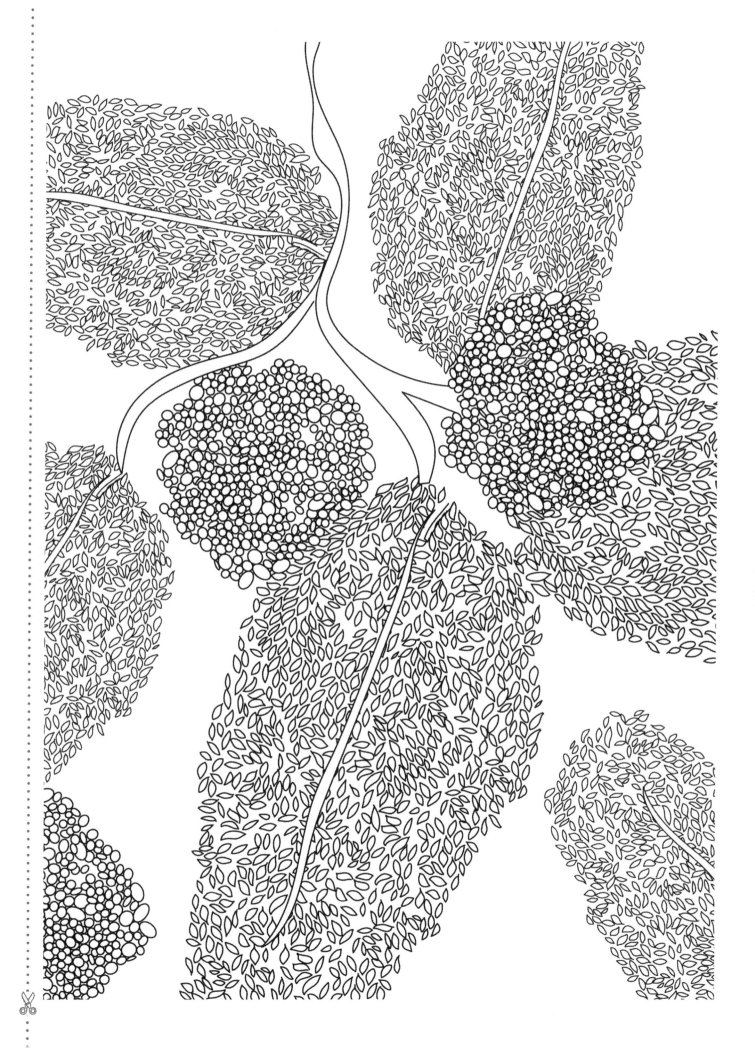

It is a wholesome and necessary thing for us to turn again to the earth and in the contemplation of her beauties to know of wonder and humility.

Rachel Carson

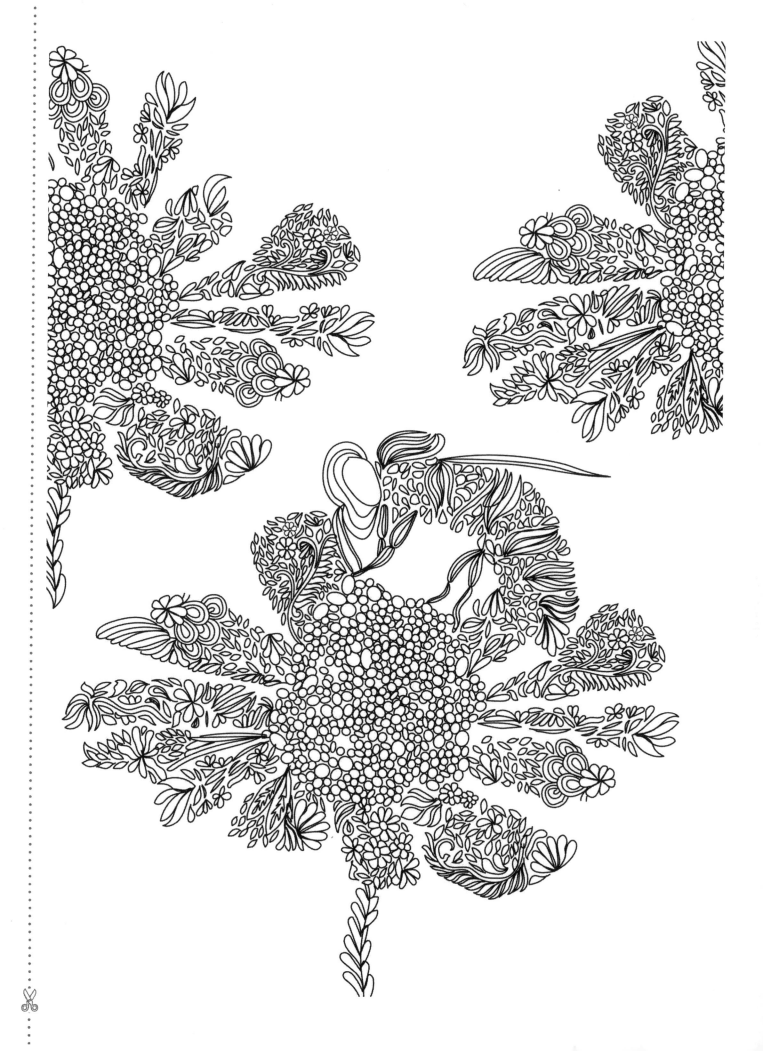

You must love the crust of the earth on which you dwell more than the sweet crust of any bread or cake. You must have so good an appetite as this, else you will live in vain. You must be able to extract nutriment out of a sand-heap. You must love the crust of the earth on which you dwell more than the sweet crust of any bread or cake.

Henry David Thoreau

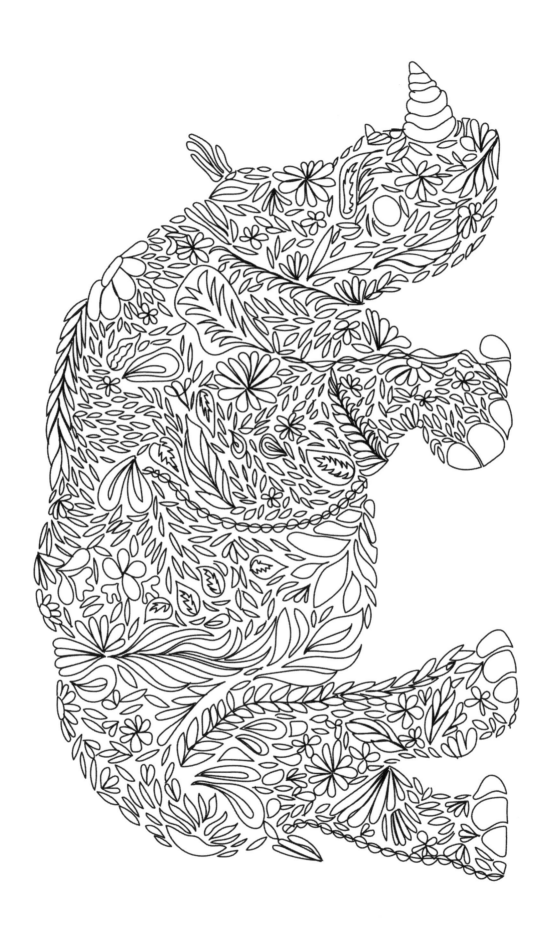

May your trails be crooked, winding, lonesome, dangerous, leading to the most amazing view.

Edward Abbey

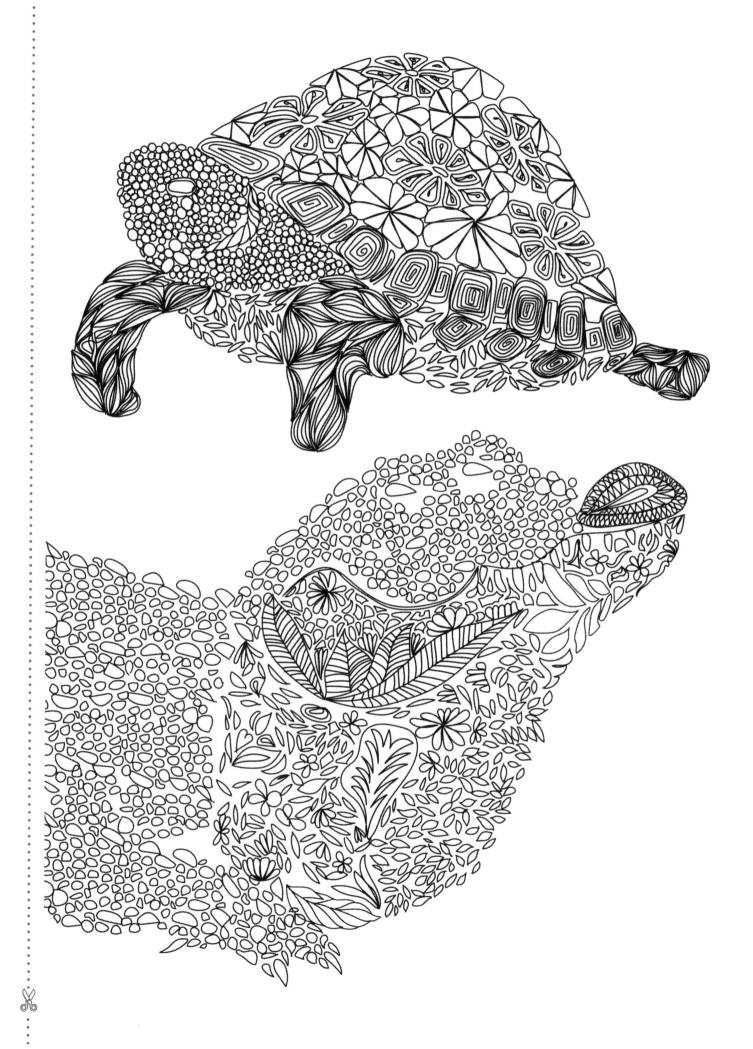

… and in her starry shade of dim and solitary loveliness, I learn'd the language of another world.

Lord Byron

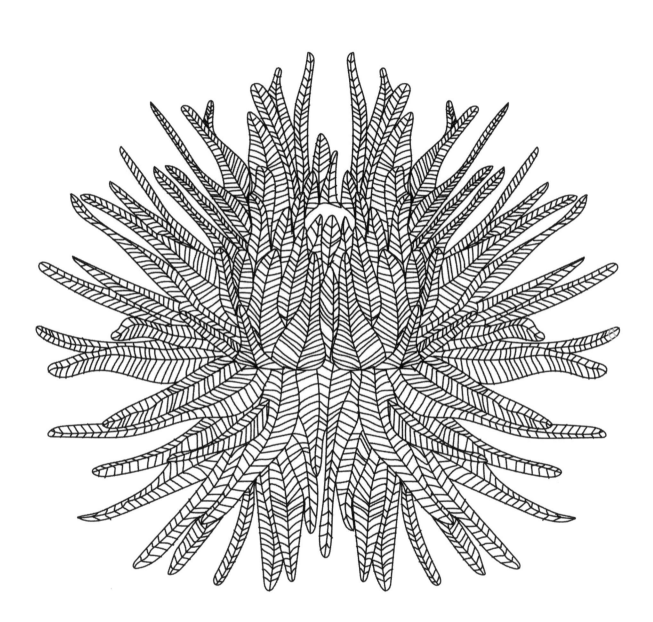

Those who contemplate the beauty of the Earth find reserves of strength that will endure as long as life lasts.

Rachel Carson

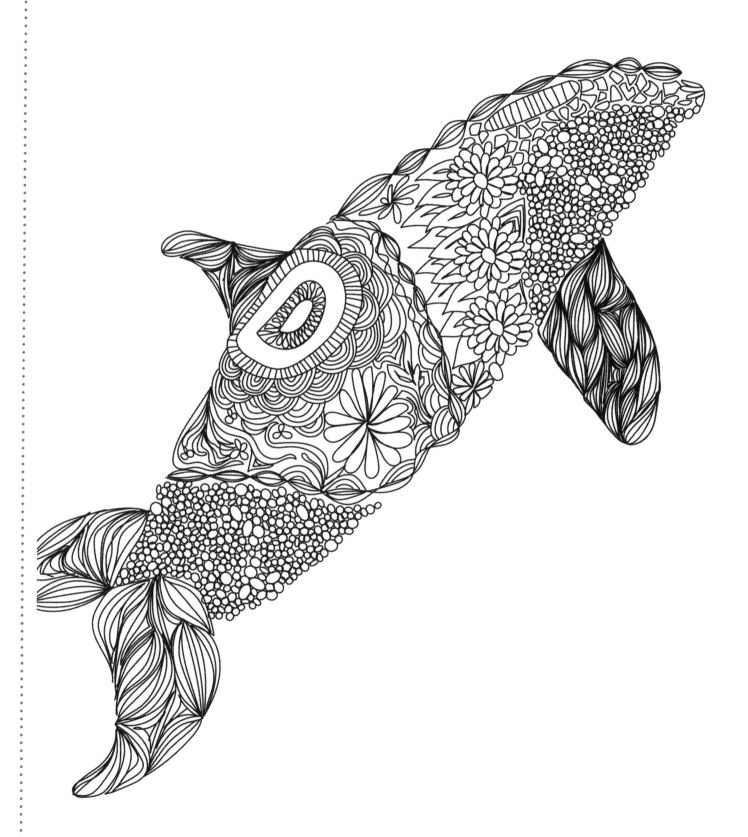

To see the summer sky is poetry, though never in a book it lie - true poems flee.

Emily Dickinson

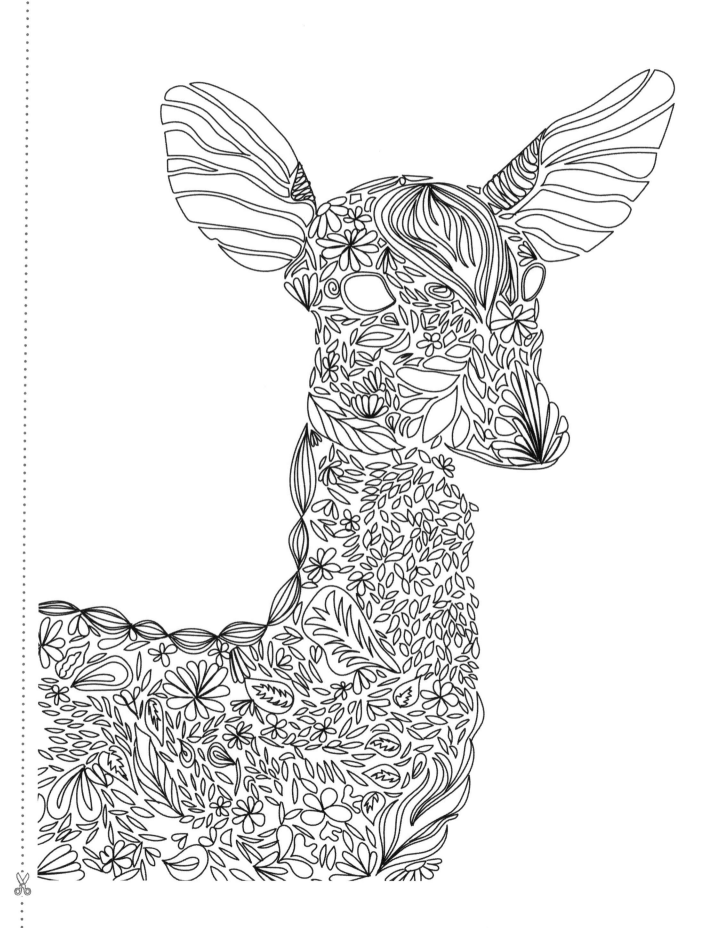

Keep your faith in all beautiful things. In the sun when it is hidden. In the spring when it is gone.

Roy Rolfe Gilson

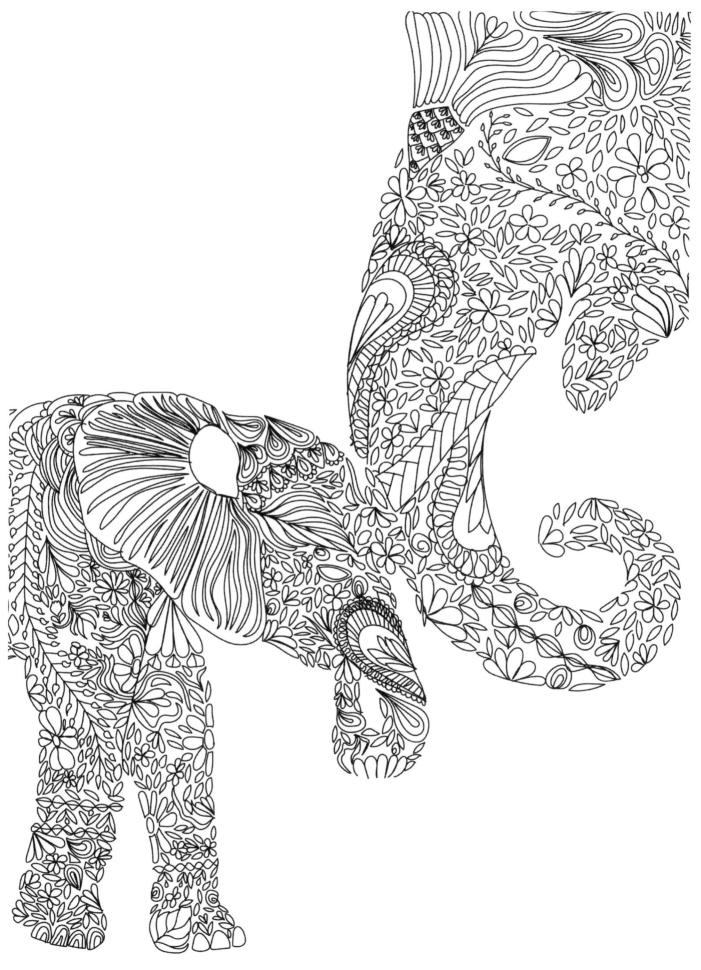

Before very long we shall have unraveled all the secrets of the universe. There will be no puzzles anymore. To me, it'd be really, really tragic because I think one of the most exciting things is this feeling of mystery, feeling of awe, the feeling of looking at a little live thing and being amazed by it.

Jane Goodall

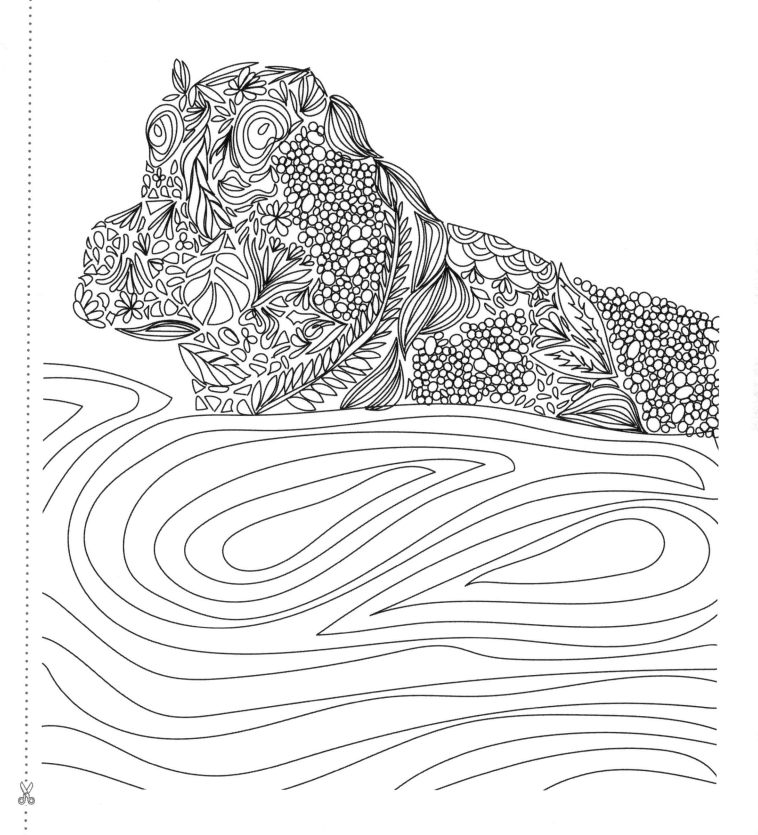

Our challenge isn't so much to teach children about the natural world, but to find ways to nurture and sustain the instinctive connections they already carry.

Terry Krautwurst

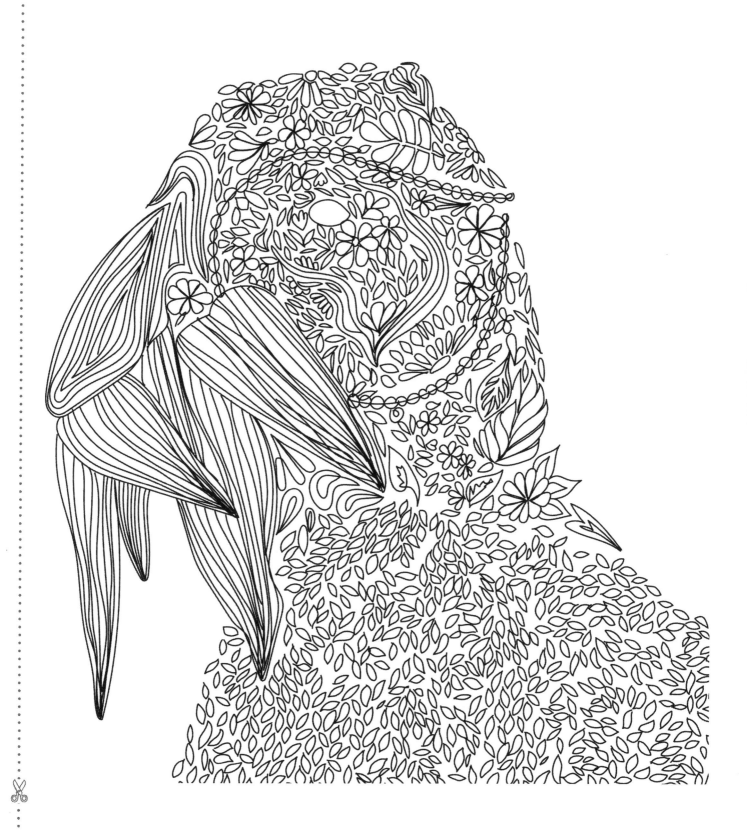

A sense of time lies thick and heavy on such a place ... Our ability to perceive quality in nature begins, as in art, with the pretty. It expands through successive stages of the beautiful to values as yet uncaptured by language.

Aldo Leopold

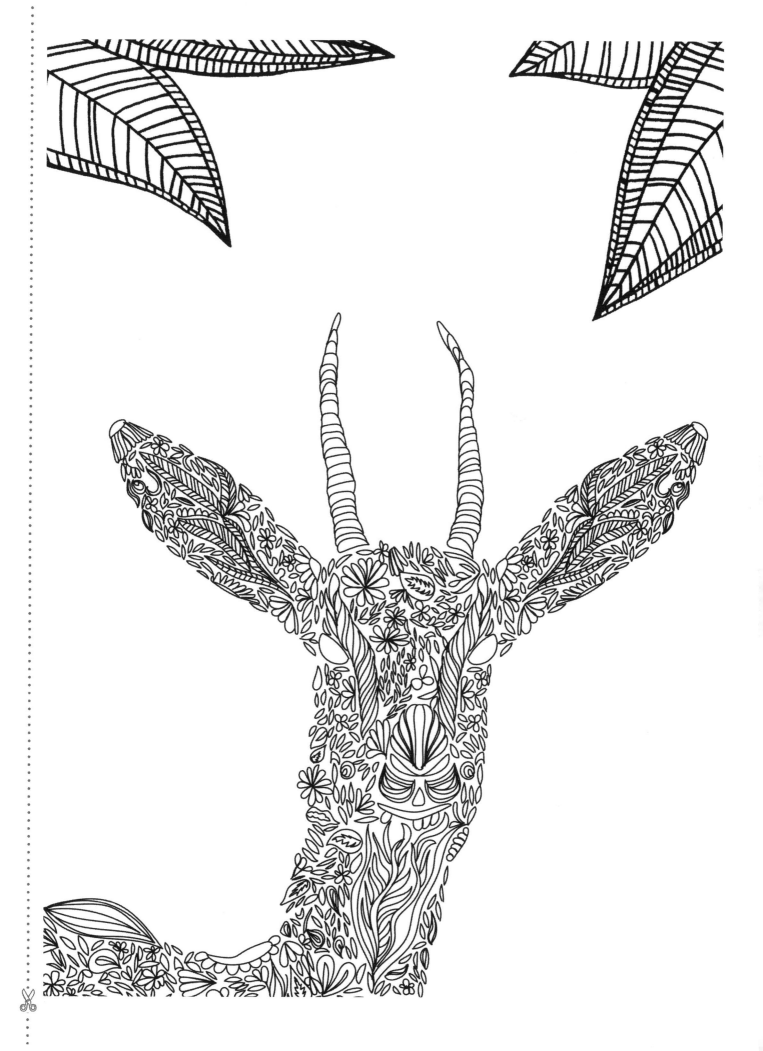

I have been studying the traits and dispositions of the "lower animals" (so called) and contrasting them with the traits and dispositions of man. I find the result humiliating to me.

Mark Twain

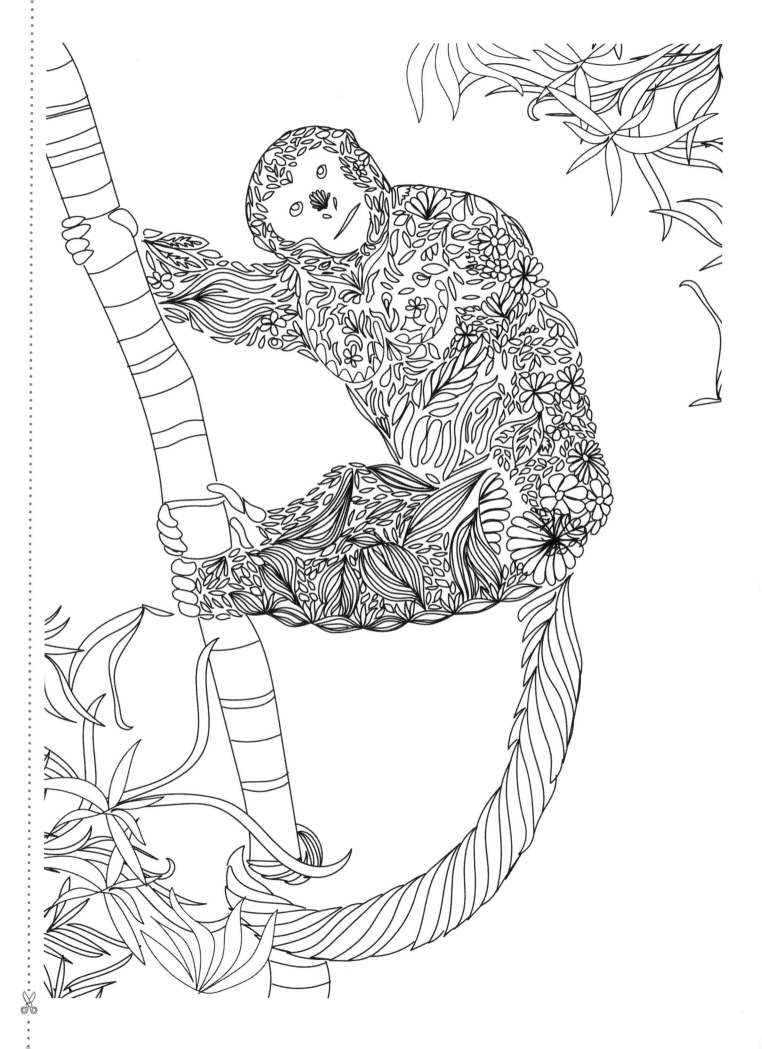

When we contemplate the whole globe as one great dewdrop, striped and dotted with continents and islands, flying through space with other stars all singing and shining together as one, the whole universe appears as an infinite storm of beauty.

John Muir

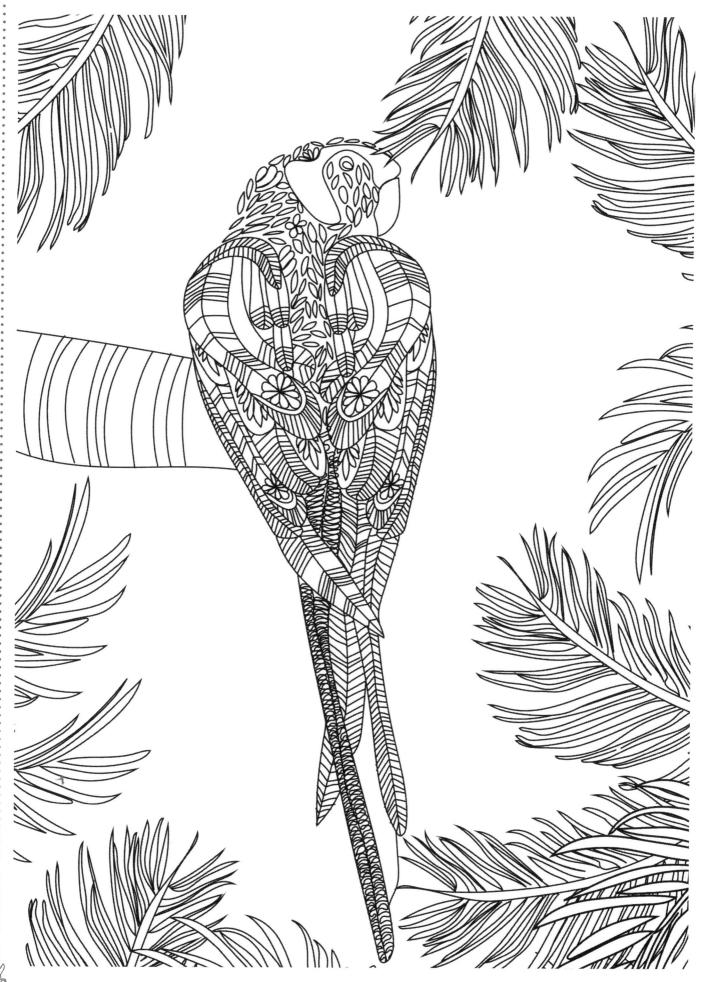

Something will have gone out of us as a people if we ever let the remaining wilderness be destroyed ... so that never again can we have the chance to see ourselves single, separate, vertical and individual in the world, part of the environment of trees and rocks and soil, part of the natural world and competent to belong in it.

Wallace Stegner

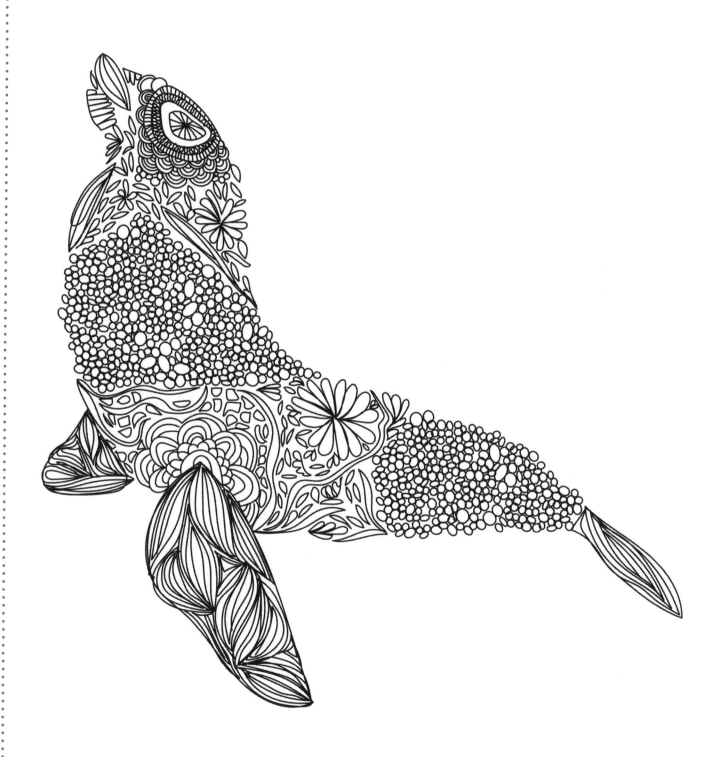

I went to the woods because I wished to live deliberately, to front only the essential facts of life, and see if I could not learn what it had to teach, and not, when I came to die, discover that I had not lived.

Henry David Thoreau

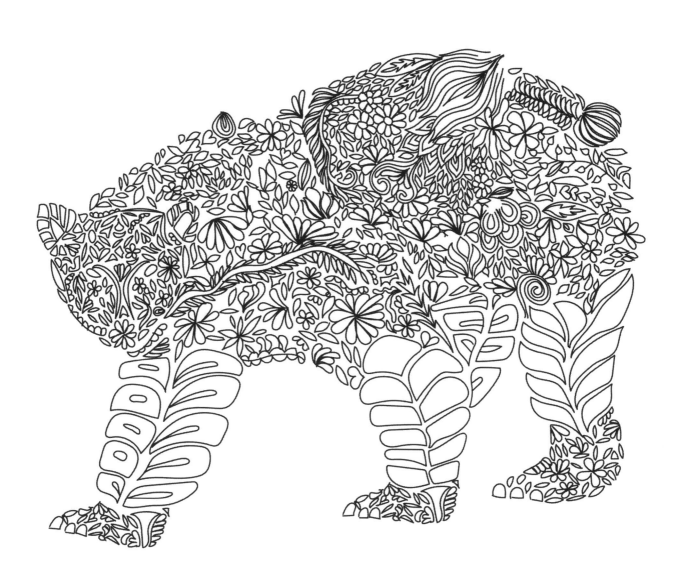
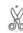

Nature never hurries. Atom by atom, little by little she achieves her work.

Ralph Waldo Emerson

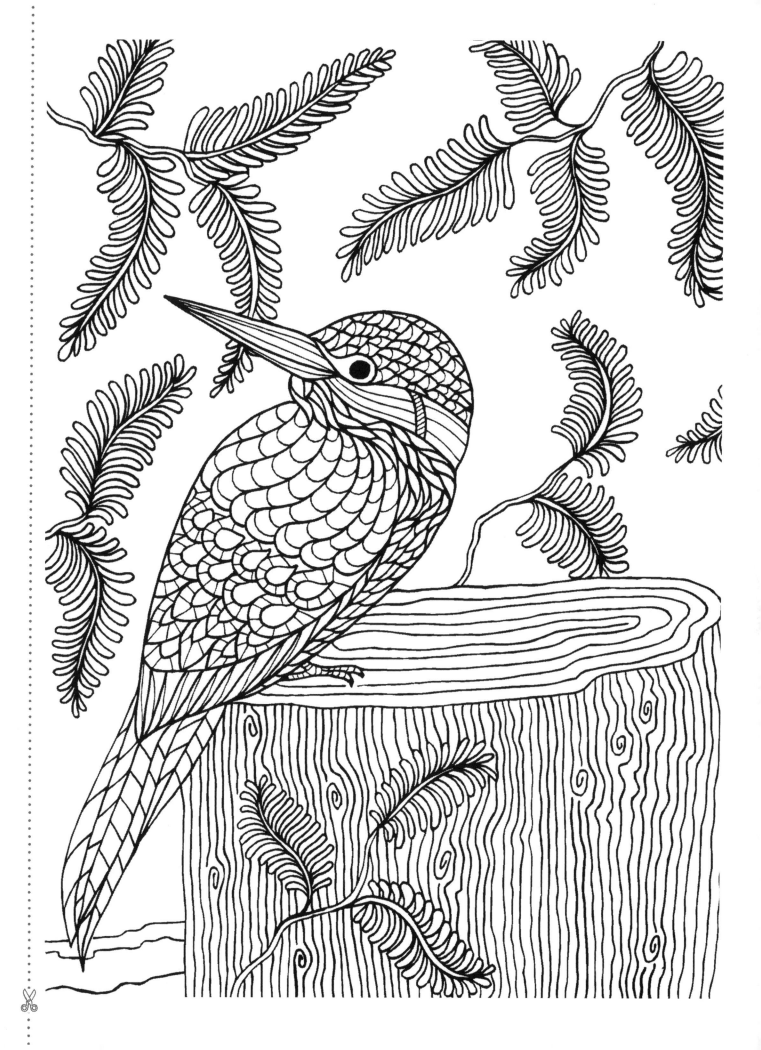

You cannot get through a single day without having an impact on the world around you. What you do makes a difference, and you have to decide what kind of difference you want to make.

Jane Goodall

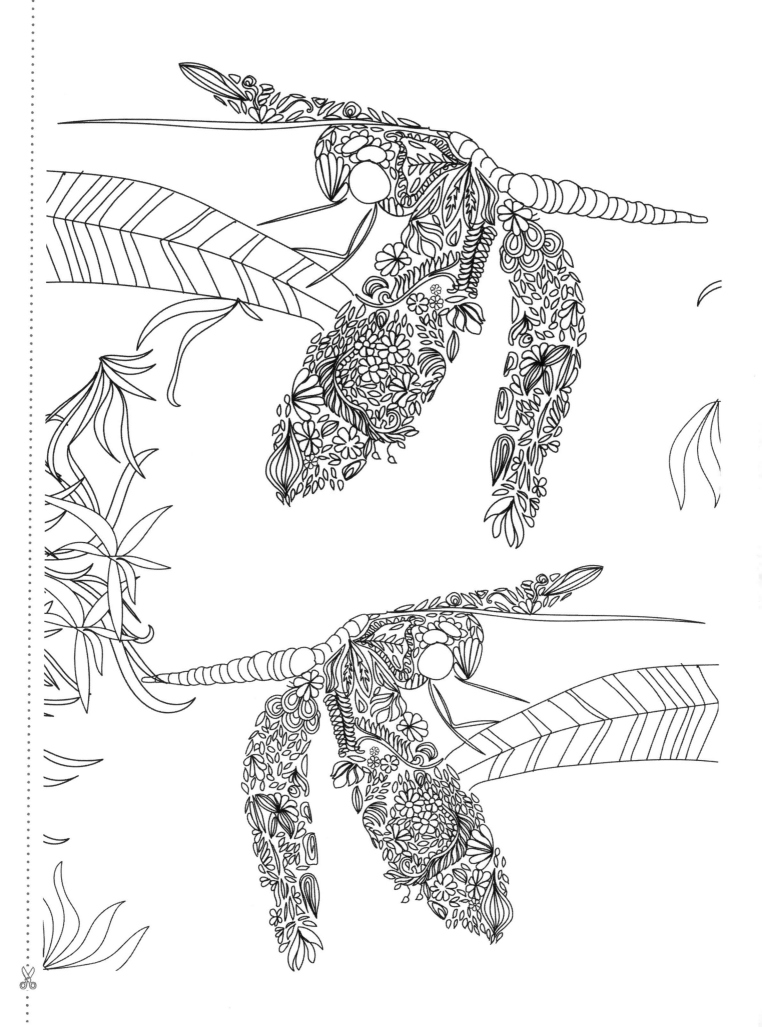

Also by Christina Rose

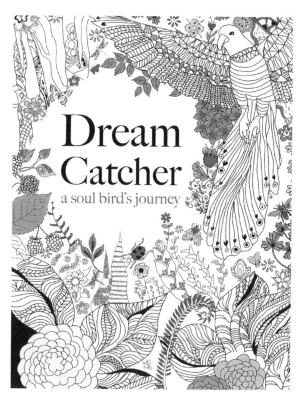

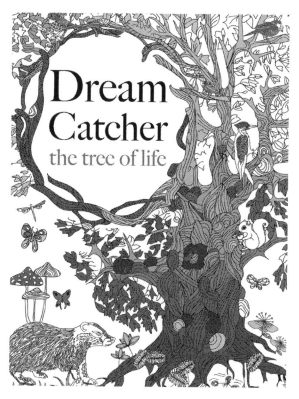

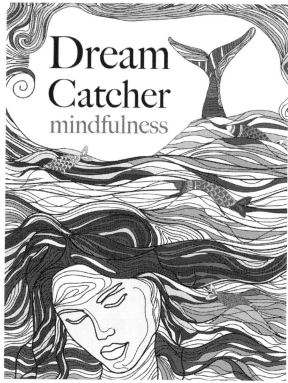

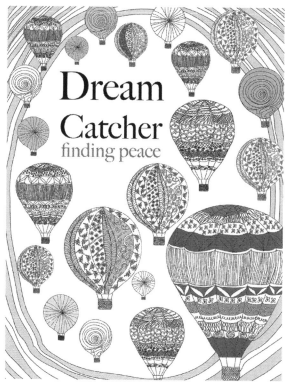

Made in the USA
San Bernardino, CA
26 February 2016